Characters have a long tradition in graffiti. From being used mainly as an accessory to graffiti letters and gracing record covers in the 80s, they nowadays take center stage.

While there are no written rules on how a graffiti character is supposed to look, the increasingly popular old school characters do have a special charm as they reflect the attitude and lifestyle of the hip hop movement. Music and fashion play a major role. Elements like sneakers, hats, chains and name belts are often incorporated, and the battle for the sharpest look is always present. You want your character to have the coolest sneakers and the fattest laces!

This book is an introduction to the world of graffiti characters. Your teacher and guide, Gess One, has more than 30 years' experience of mastering graffiti characters. You will learn how to add that stylish flavor to your figures and give them that sharp look and attitude. You can use separate papers to do each exercise several times, and with a little bit of practice you too will develop your own style. Enjoy!

GRAFFITI CHARACTERS FOR BEGINNERS
Arnd Schallenkammer / Gess One
ISBN 978-91-88369-73-4
© 2022 Dokument Press & Arnd Schallenkammer
Printed in Poland
First printing

Dokument Press, Årstavägen 26, 120 52 Årsta, Sweden
www.dokument.org I info@dokument.org I @dokumentpress

DOKUMENT
PRESS

MATERIALS AND TOOLS

Out of all the tools used for drawing, the pencil is among the most essential. Softer grade pencils allow for darker lines, and by changing the degree of hardness you can single out and emphasize the lines you want to use in the underlying sketch. Use an eraser to clean up the drawing.

A sketchbook is useful as it allows you to keep your drawings together. However, any paper can be used for drawing.

Fineliners are suitable for creating the final version. As with pencils, fineliners are available in different colors and a range of tip sizes.

Modern hardware, such as a tablet, is a great alternative and has the advantage of little or no paper consumption.

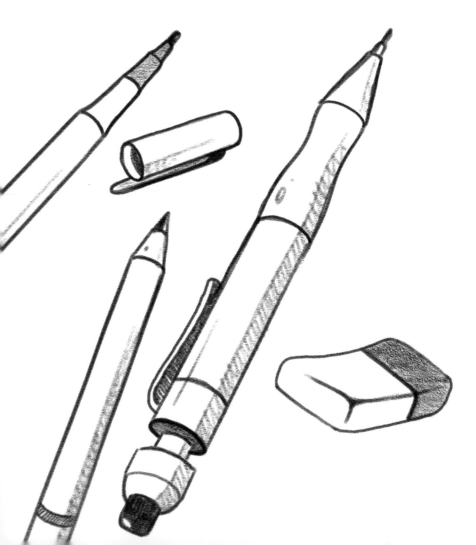

FACIAL PROPORTIONS

While each person's face is unique, there are some general proportions that can be applied when you're drawing. As an artist you're free to draw however you like, but knowing these proportions will increase your flexibility and facilitate the process when drawing faces.

- The width of the head corresponds to 5 times the width of the eye.
- The head is divided into 3 horizontal sections of equal height (a).
- The hairline is half the height of (a). The eyes are located approximately in the middle of the head.
- The bottom horizontal section is divided into 3 equally sized parts (b).
- The mouth sits on the second line of the bottom section.
- The corners of the mouth are in line with the centre of the eyes.
- The height of the ears corresponds to the distance between the lower edge of the nose and up to the eyebrow.

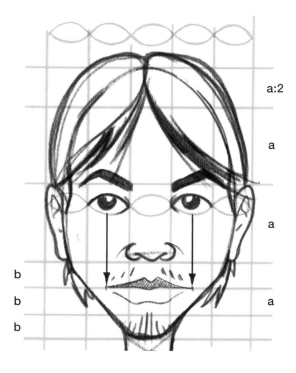

An ellipse can be used as a basic shape for the face.

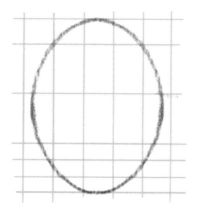

The position of the eyes changes depending on the direction
from which we are viewing the head.

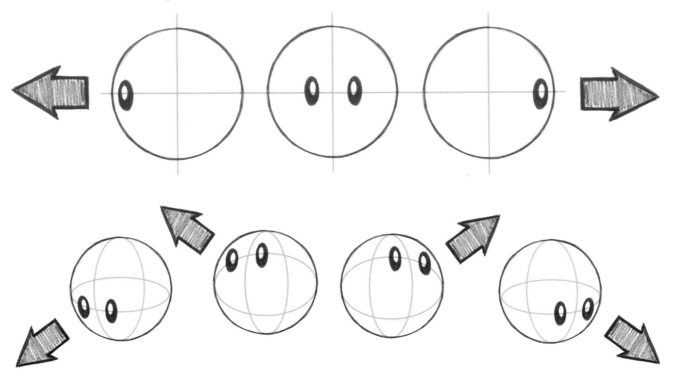

These are alternative ways of shaping a head. Now draw different head shapes,
and later use what you have learned about positioning the eyes, ears and mouth.
The heads can have any shape you like.

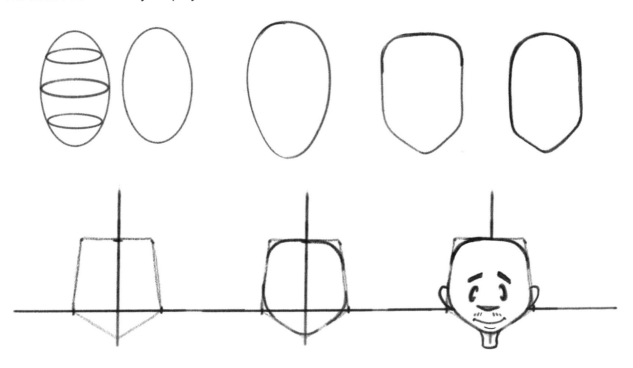

Step-by-step instruction for how to draw a classic old school character's head in profile.
Note that in each step you have the option of customizing the face any way you like.

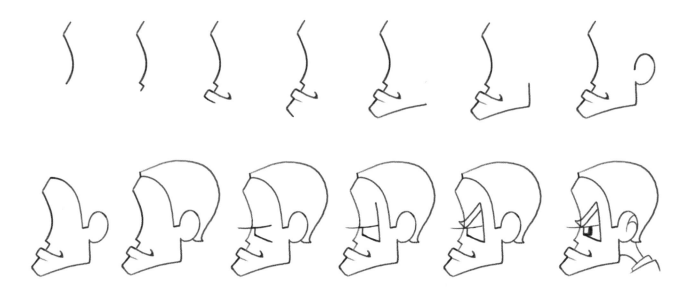

The back of the head as well as the chin, the forehead and other elements
are all variable. Different effects can also be achieved by rounding.
The more angular a face is, the more aggressive it appears.

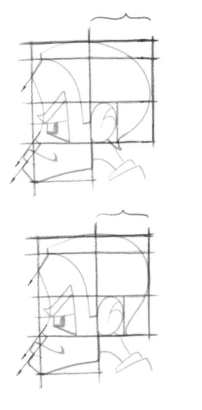
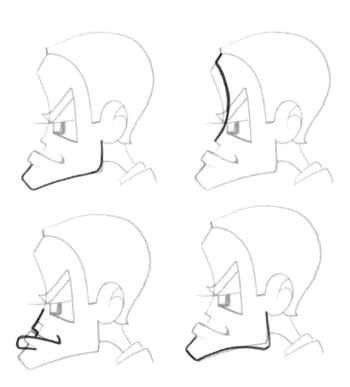

EYES, MOUTH, NOSE AND EARS

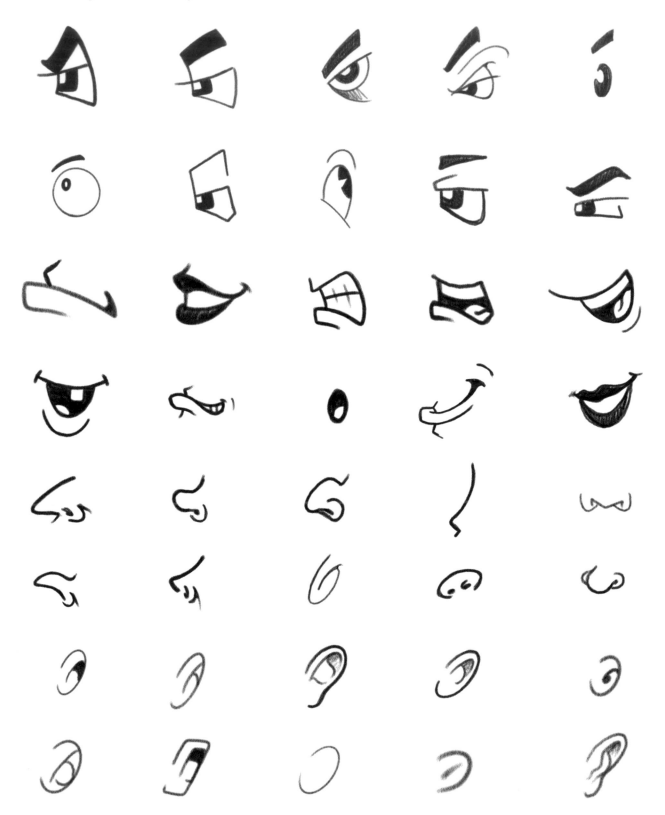

EMOTIONS

Depending on the position of the eyes, eyebrows and mouth, you can give your character different emotions. See below for some examples.

HEAD

EXERCISE

Complete the character at different levels of difficulty. Finalize the figures by adding the missing lines to the templates below and note the original character's details.

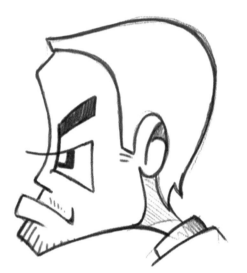

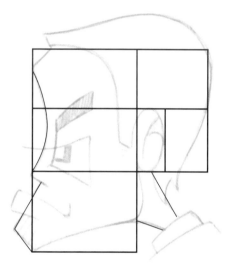

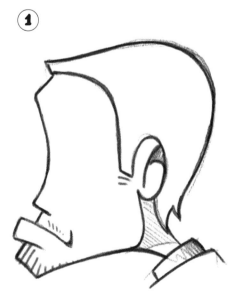

(1)

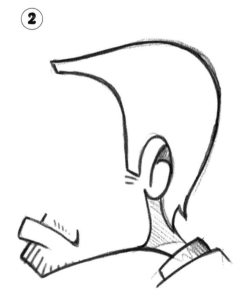

(2)

③
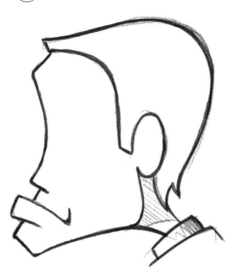

④
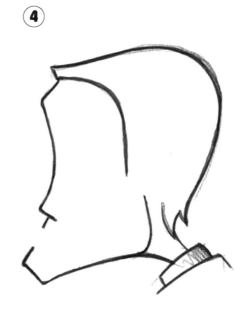

⑤
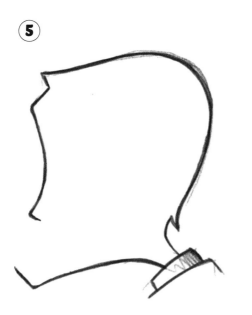

⑥

HEAD

EXERCISE

Complete the character.

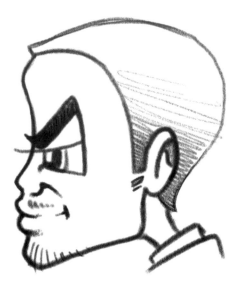

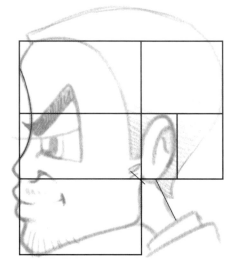

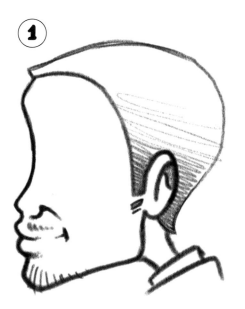

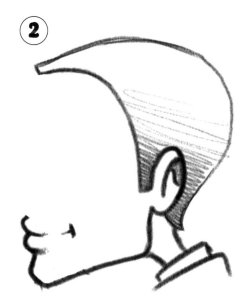

3

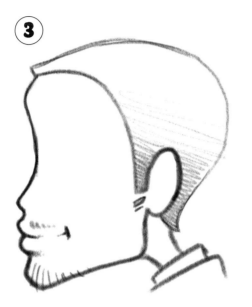

4

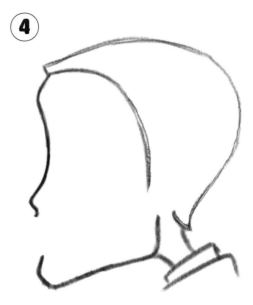

5

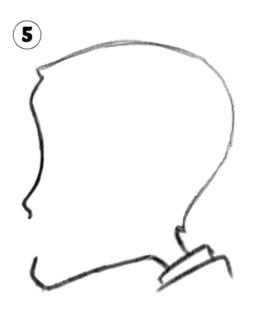

6

HEAD

EXERCISE

Complete the character.

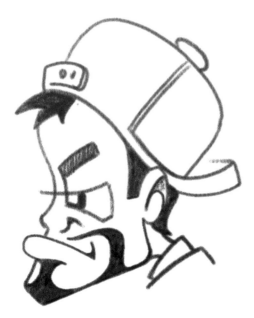

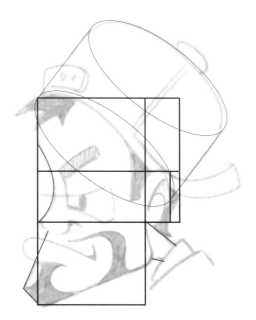

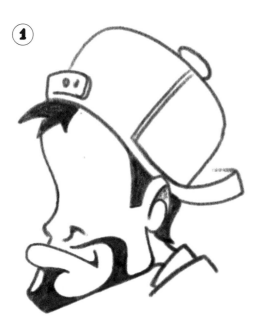

①

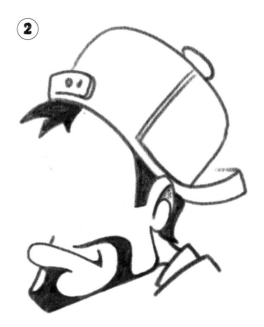

②

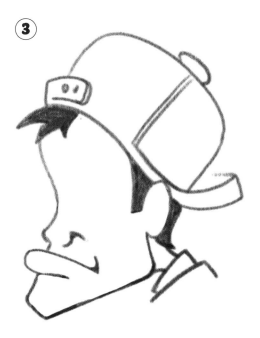

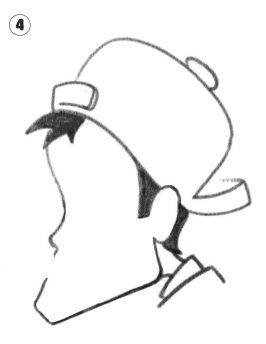

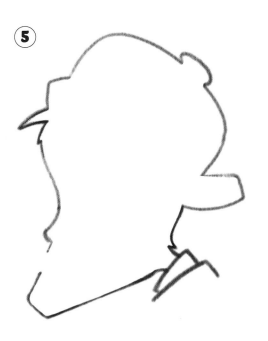

HEAD

EXERCISE

Complete the character.

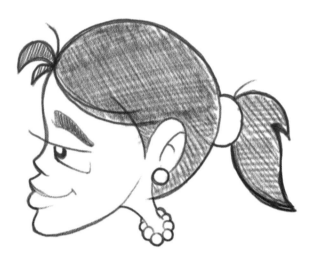

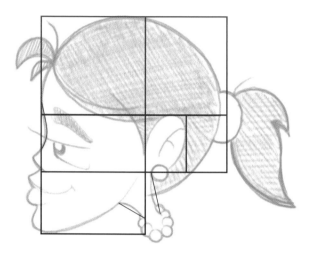

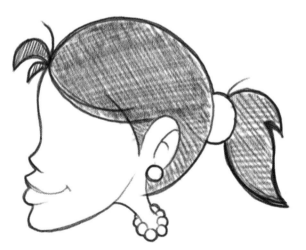

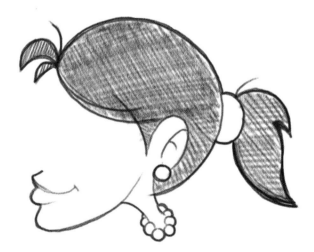

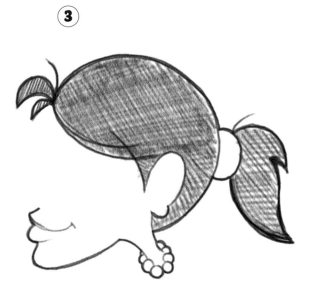

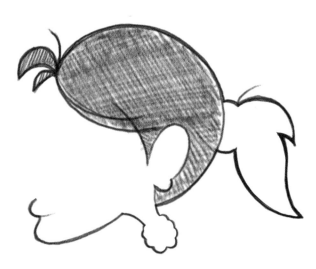

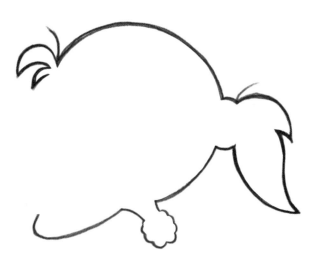

HEAD

EXERCISE

Complete the character.

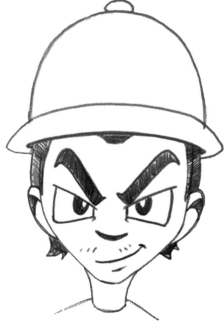

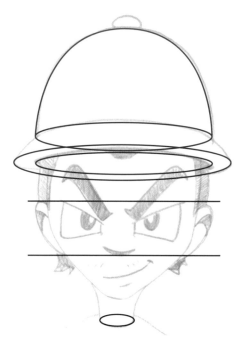

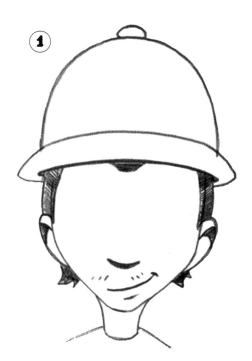

①

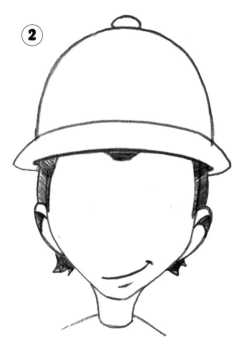

②

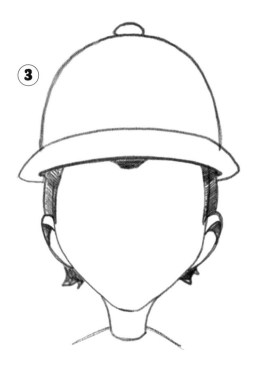
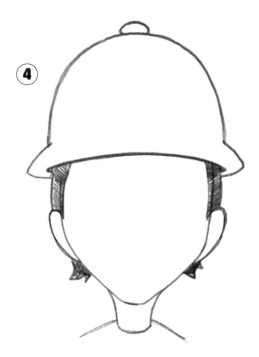
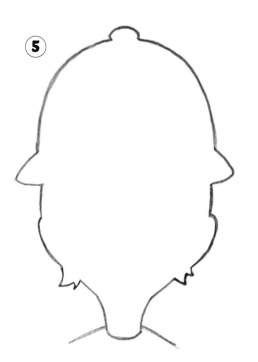

FASHION AND ACCESSOIRES

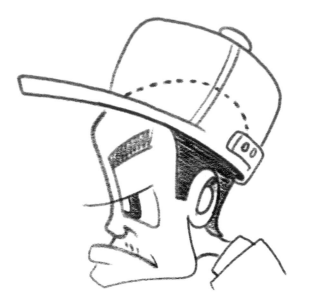

Fashion has always been important in hip hop. There's an ongoing battle for having the hottest clothes. Hats, glasses, name belts, and of course sneakers.

On the following pages you will find examples of different clothes and accessories that are common for graffiti characters. You will learn what they represent and what to think about when you draw them.

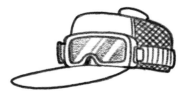

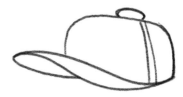
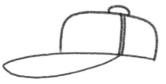

EXERCISE

Choose a hat from the adjacent page and
complete the drawings below.

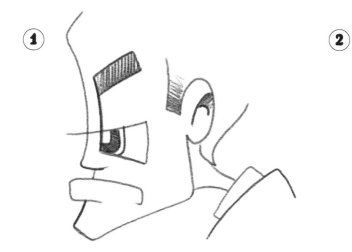

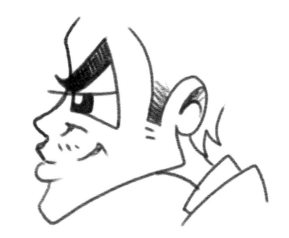

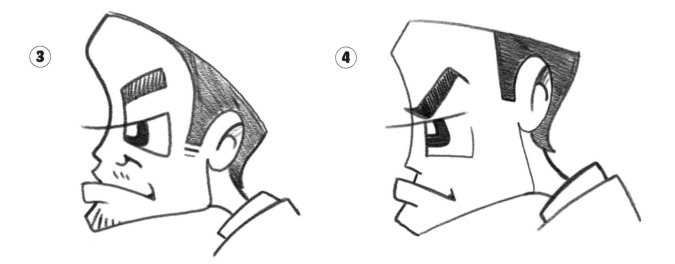

FASHION AND ACCESSOIRES

Name belts and name rings became very popular in the early days of hip hop and have been fashionable ever since.

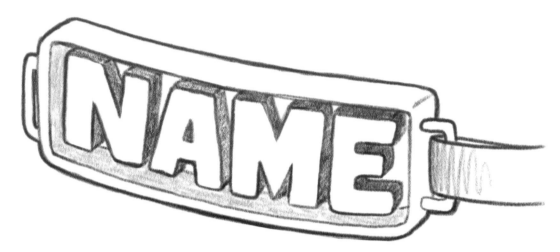

In their most simplified form, name belts consist of a rectangle. Inside the rectangle you can add any type of letters, such as block letters or graffiti letters. Just keep in mind that the rectangle frames the letters and that they need to be kept inside it.

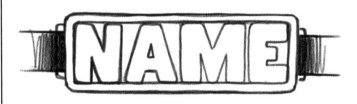

Name rings are similar to name belts, and as with name belts the shape of the letters are restricted by the rectangular frame. Note that you need to pay attention to the way the perspective of the ring changes with the posture of the hand.

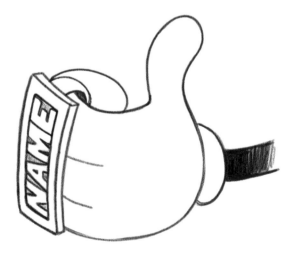

Cash, flashy jewelry, cars and other expensive things are common in hip hop. In rap videos, status symbols such as gold chains and dollar bills play an important role in showing off the artist's success.

The Africa medallion was hugely popular within the hip hop movement in the late 80s.

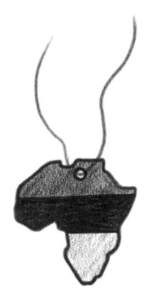

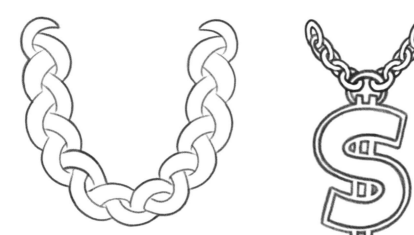

Glasses are another status symbol that has never gone out of fashion.

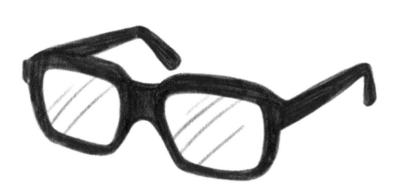

On the right you'll find examples of how to draw glasses in a simplified way. Classic graffiti characters often wear thick Cazal spectacle frames or ski goggles.

FASHION AND ACCESSOIRES

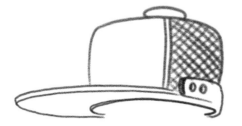

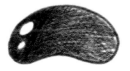

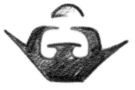

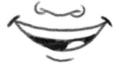

EXERCISE

Add style to the faces below. Design something of your own or choose from the hats and glasses shown on the adjacent page.

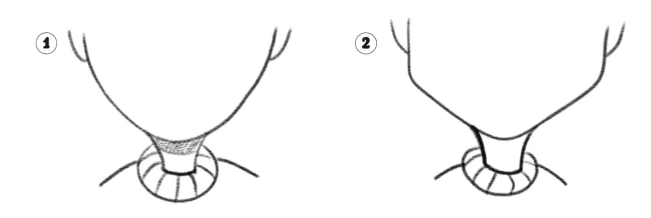

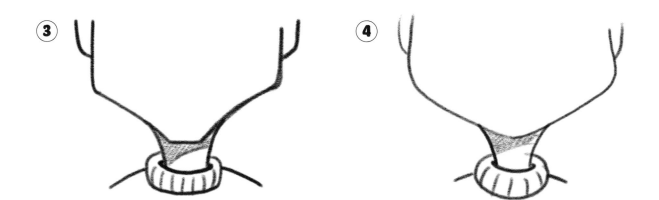

HANDS

The basic shape of a hand can be drawn as a circle or a trapezoid, where the trapezoid is the more realistic shape.

Consider the differences in length between each finger and that they radiate outwards at different angles. In more complex positions it's important to take the finger joints into account. For example when the hand is communicating an attitude. This is usually not as relevant for comic characters.

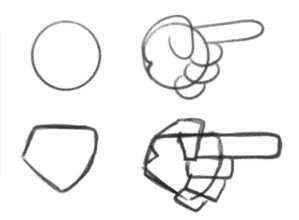

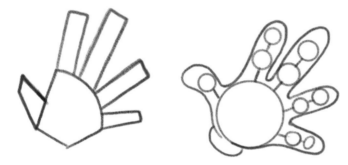

The joints can be marked by dots and connected with lines in order to view the angle of each finger.

The images below show examples of open and closed hand gestures as well as hands holding objects. Since evil characters are often featured in graffiti, different kinds of weapons are not uncommon.

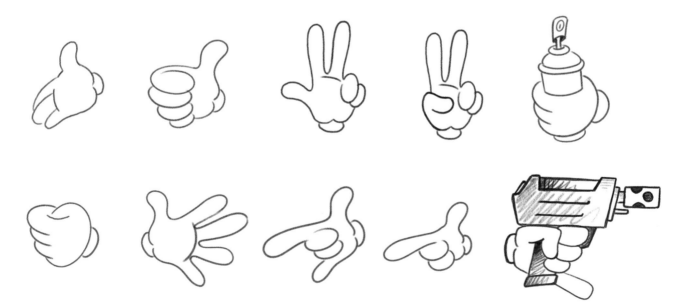

SHOES

Shoes are usually shown at a slight angle. Classic sneaker models such as Puma Suede and Adidas Superstar are a safe bet. Fat laces are important for a classic graffiti character, and the more colors they have the better.

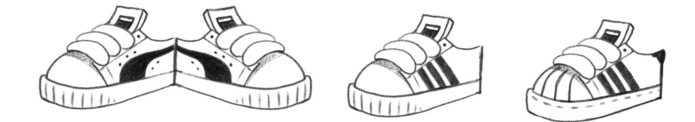

As with parts of the body, using a basic geometric framework such as the one below is helpful when drawing shoes.

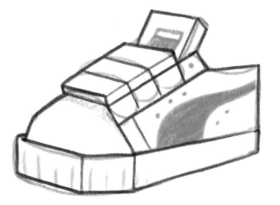
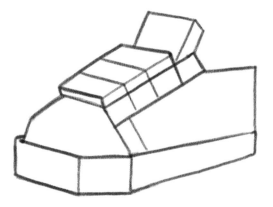

A common variation is a position where one shoe is shown from the side and the other one from the front.

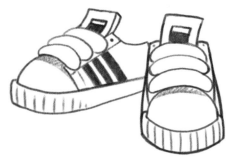

UPPER BODY
COMPLETE THE CHARACTER

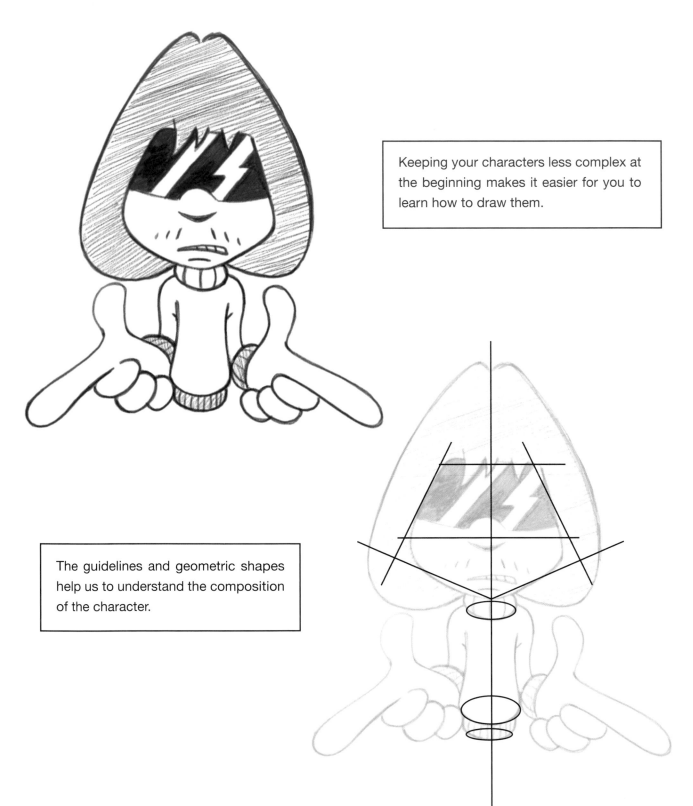

Keeping your characters less complex at the beginning makes it easier for you to learn how to draw them.

The guidelines and geometric shapes help us to understand the composition of the character.

EXERCISE

Complete the character at different levels of difficulty. Finalize the figures by adding the missing lines to the templates below and note the original character's details on the adjacent page.

UPPER BODY

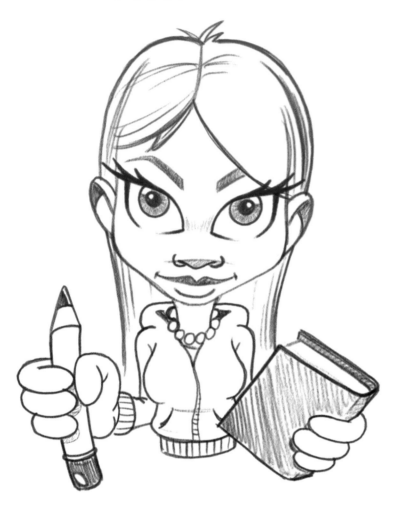

Female characters are generally drawn with somewhat softer shapes than male characters. The hips are the widest point on the female body and the rib cage is narrower. Women's eyes are often drawn larger and rounder, since big wide-open eyes make the face look more feminine. Eyebrows tend to be narrow with a steep angle, and the lips are thicker with a top curvature like a flattened "M".

The guidelines and geometric shapes help us to understand the composition of the character.

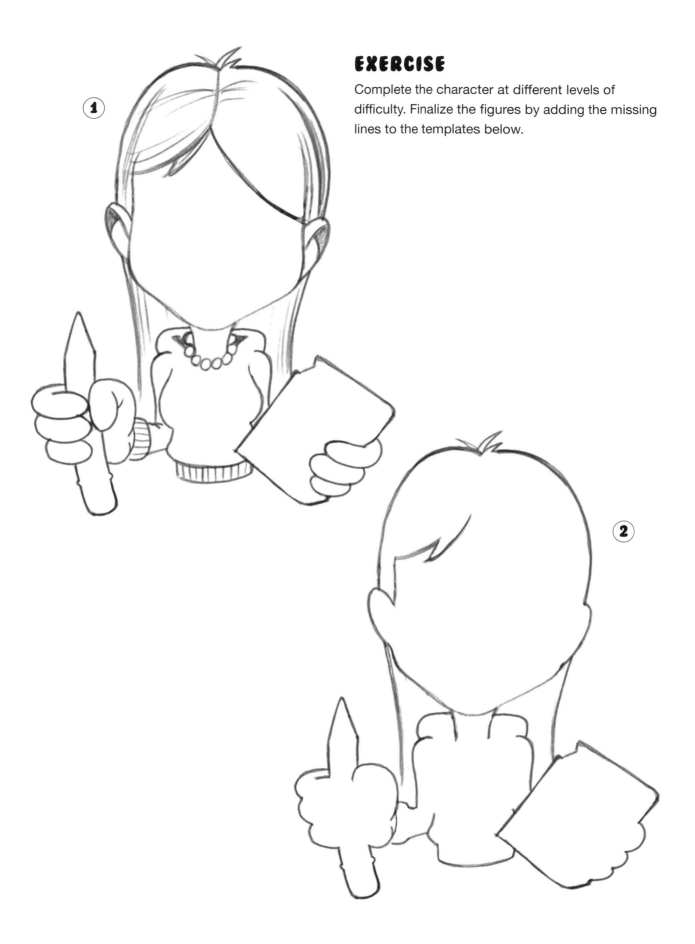

EXERCISE

Complete the character at different levels of difficulty. Finalize the figures by adding the missing lines to the templates below.

UPPER BODY

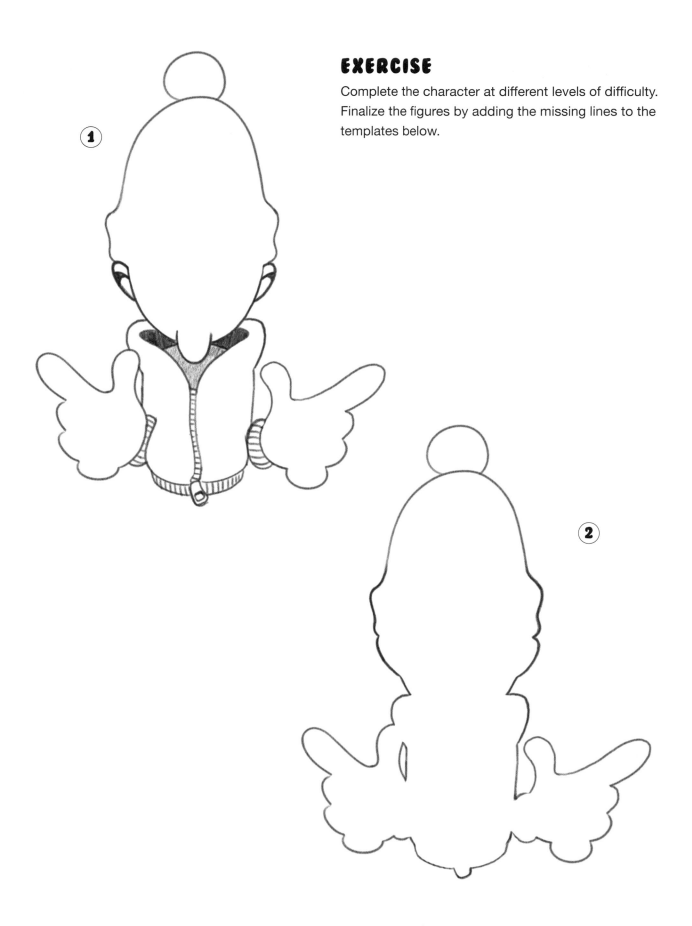

EXERCISE

Complete the character at different levels of difficulty. Finalize the figures by adding the missing lines to the templates below.

UPPER BODY

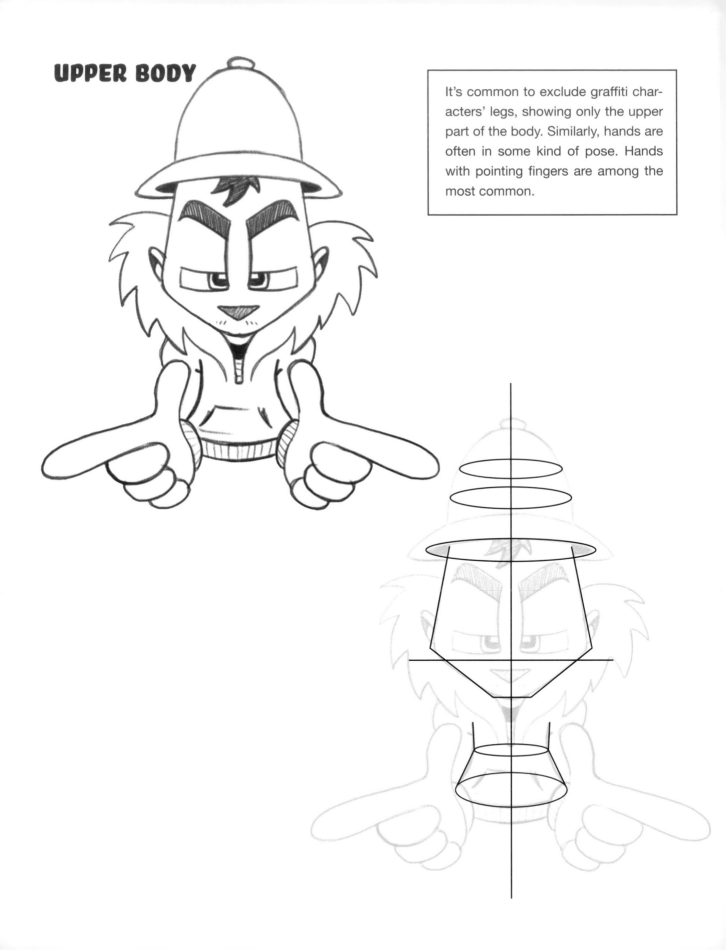

It's common to exclude graffiti characters' legs, showing only the upper part of the body. Similarly, hands are often in some kind of pose. Hands with pointing fingers are among the most common.

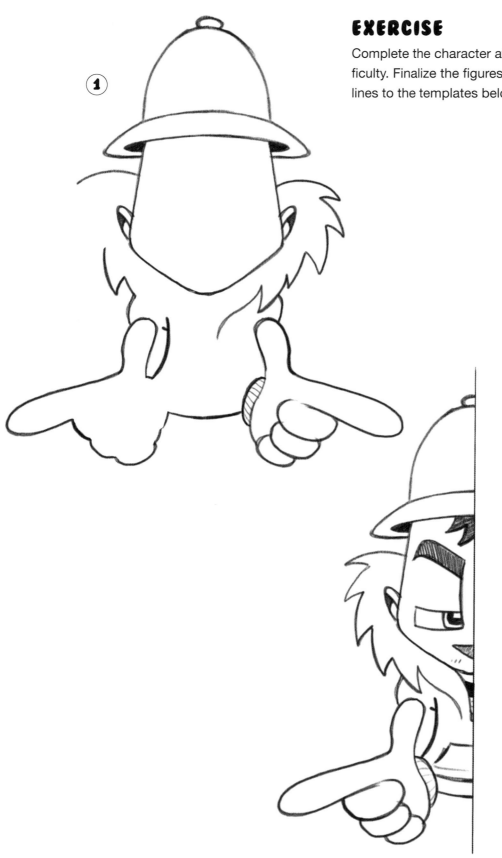

EXERCISE

Complete the character at different levels of difficulty. Finalize the figures by adding the missing lines to the templates below.

DRAWING A FULL BODY CHARACTER

Start by thinking about the pose you want your character to have. Then try to sketch it using geometric shapes. One way to do the basic figure is to first draw the central line of the body and later divide the body parts into three-dimensional shapes like spheres (shoulders and knees) or cylinders (legs and arms). In the next step you refine the shapes and fill in the lines you want to use. Complete the drawing by adding details and erasing superfluous lines.

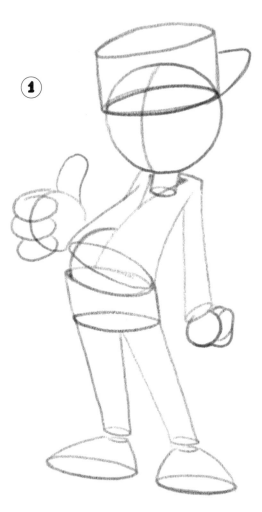

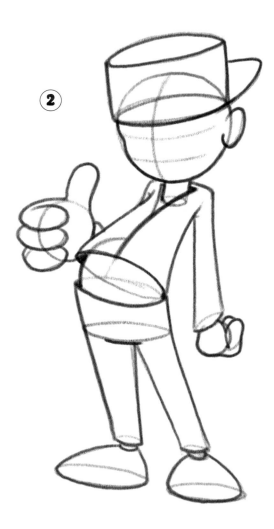

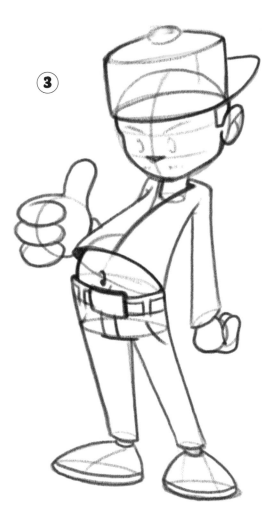

③

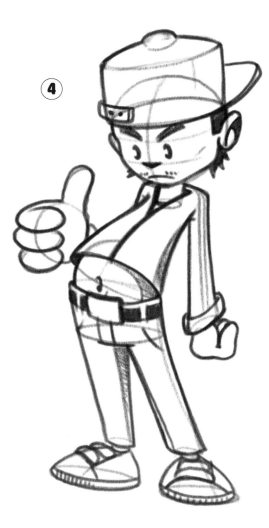

④

FULL BODY

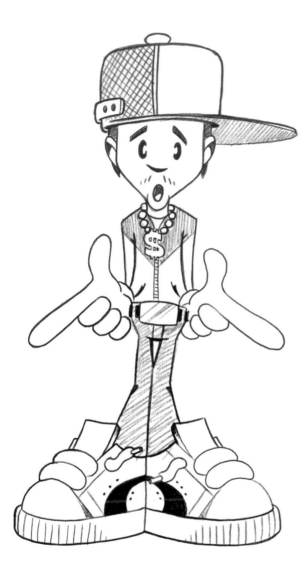

Drawing a complete figure is the ultimate skill. Use what you've learned earlier in this book when completing this exercise and remember that using an image or photo as a guide when drawing the pose will make it easier to get the proportions right.

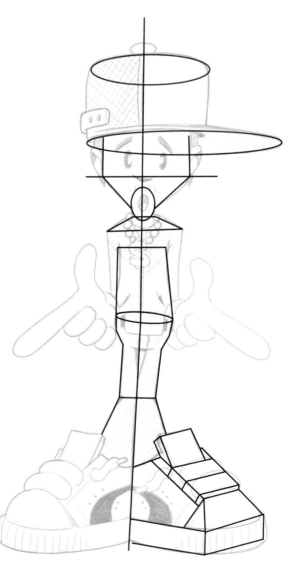

The guidelines and geometric shapes help us to understand the composition of the character.

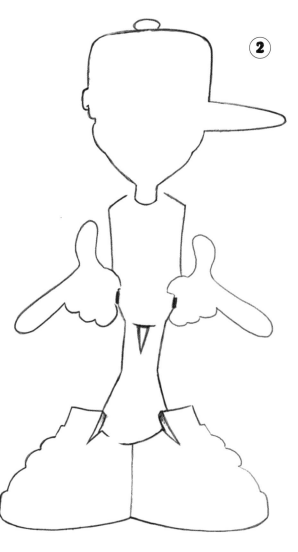

EXERCISE

Complete the character at different levels of difficulty. Finalize the figures by adding the missing lines to the templates below and note the original character's details on the adjacent page.

FULL BODY

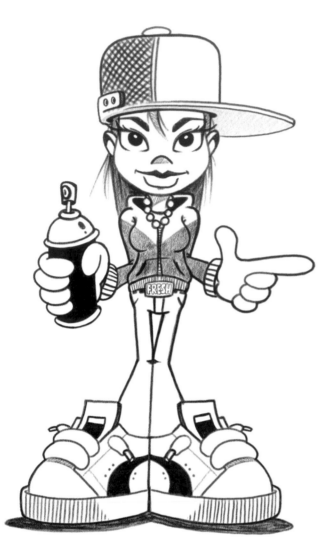

An essential difference between a male and a female body is found around the waist. Males tend to have wider torsos, while females tend to have wider hips, which also makes the female waist look thinner.

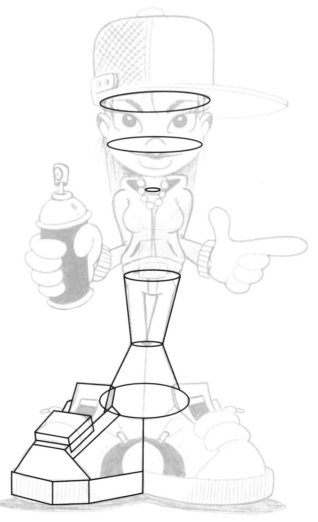

The guidelines and geometric shapes help us to understand the composition of the character.

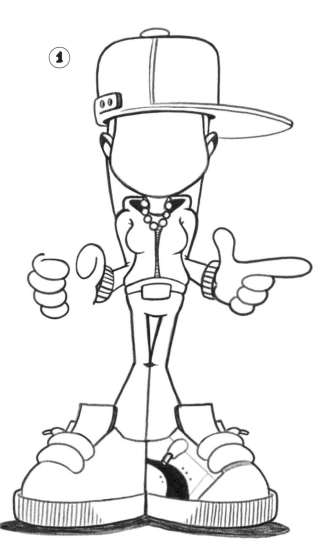

EXERCISE

Complete the character at different levels of difficulty. Finalize the figures by adding the missing lines to the templates below.

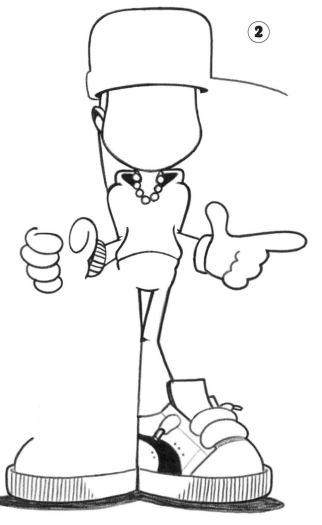

FULL BODY

When drawing full body figures it's important to understand how the proportions of the different body parts relate to one another. While it's certainly possible to exaggerate the size or proportion of certain parts, they still need to relate correctly to the remaining parts for the character to look good.

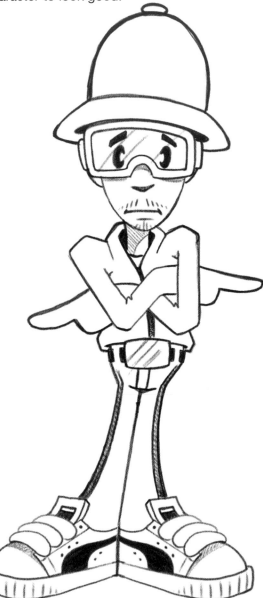

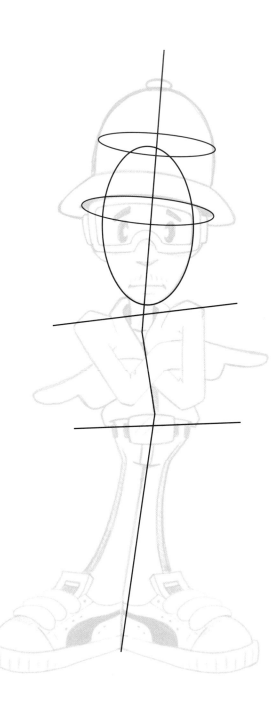

The guidelines and geometric shapes help us to understand the composition of the character.

EXERCISE

Complete the character at different levels of difficulty. Finalize the figures by adding the missing lines to the templates below.

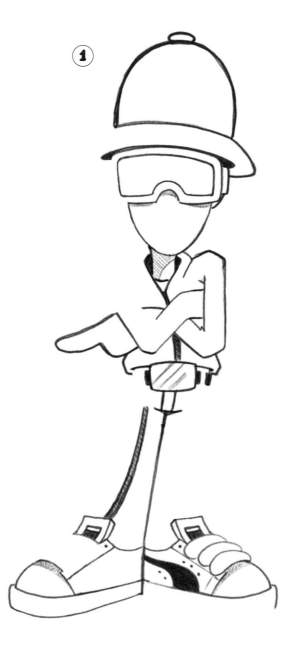

FULL BODY

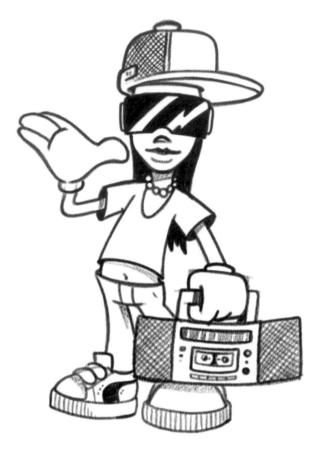

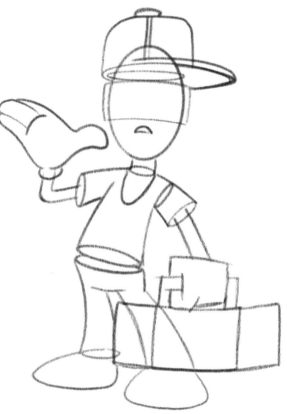

EXERCISE

Complete the character at different levels of difficulty. Finalize the figures by adding the missing lines to the templates below.

①

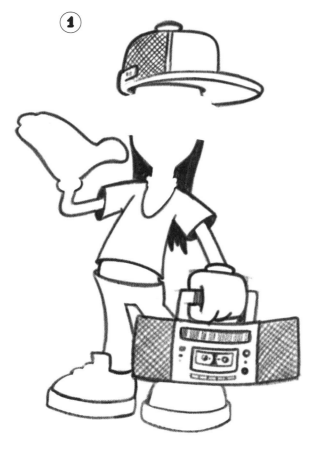

②

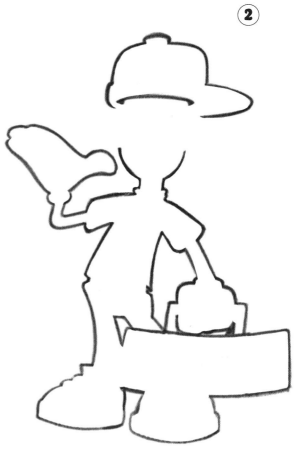

FULL BODY

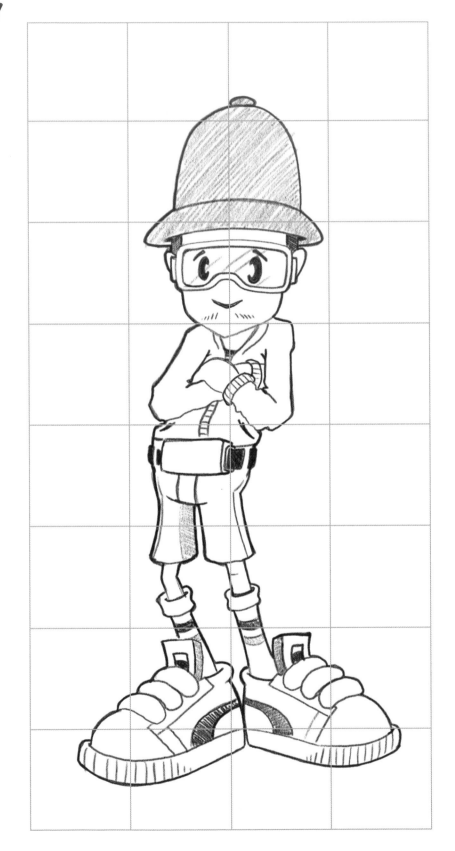

EXERCISE

Use the grid to facilitate transferring the character into the square below. The grid is also a good tool for enlarging figures.

NON-HUMAN CHARACTERS: THE BOMB

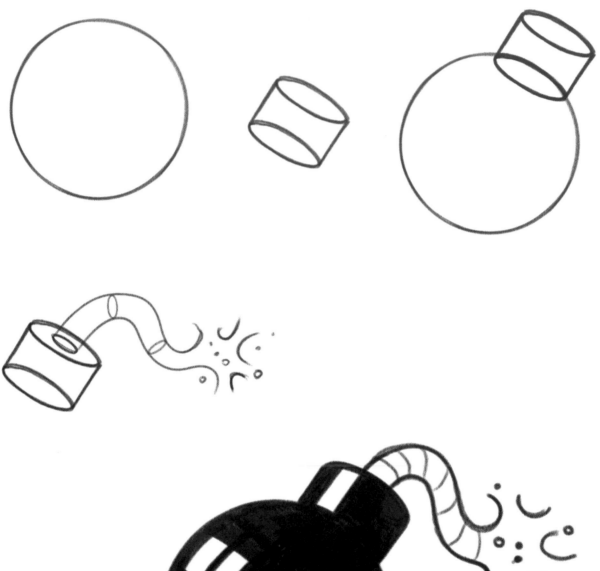

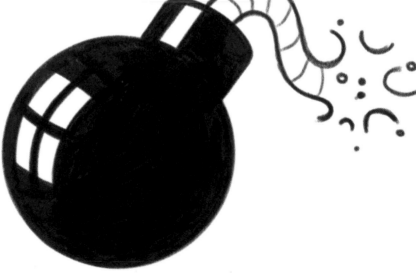

EXERCISE

Complete the character at different levels of difficulty. Finalize the figures by adding the missing lines to the templates below and note the original character's details.

①

②

③

④

NON-HUMAN CHARACTERS: THE LIVING SPRAY CAN

The living spray can, also known as the "Crime Can", is a popular character in graffiti, and drawing it is relatively easy.

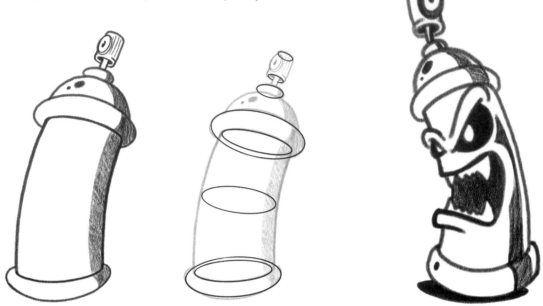

The basic shape of the spray can body is a cylinder. The upper part of the can forms a half sphere with a ring on top (in which the nozzle is inserted). The nozzle is also based on a cylinder shape. Finally, to breathe life into the can it needs a face. Eyes are the most important detail to add, followed by a mouth. Nose and ears are optional.

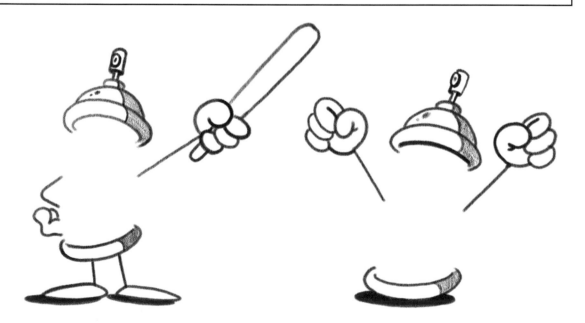

EXERCISE

Complete the character at different levels of difficulty. Finalize the figures by adding the missing lines to the templates below.

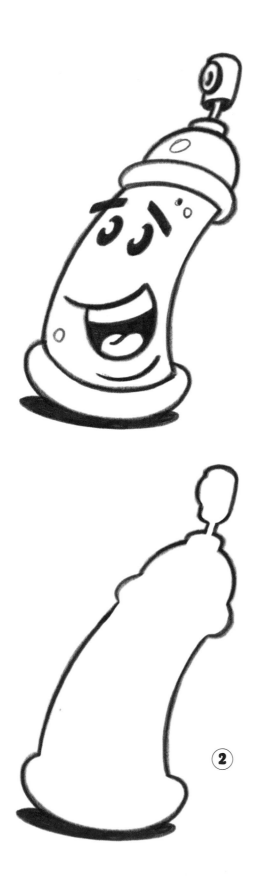

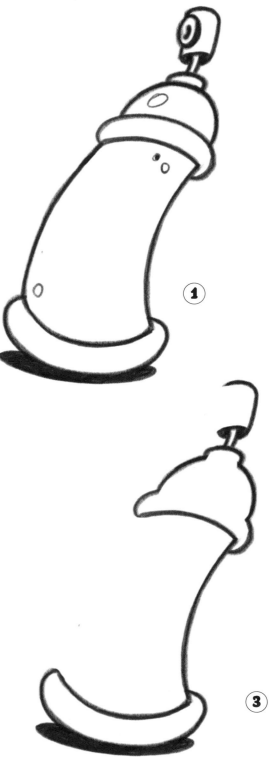

NON-HUMAN CHARACTERS: THE MARKER

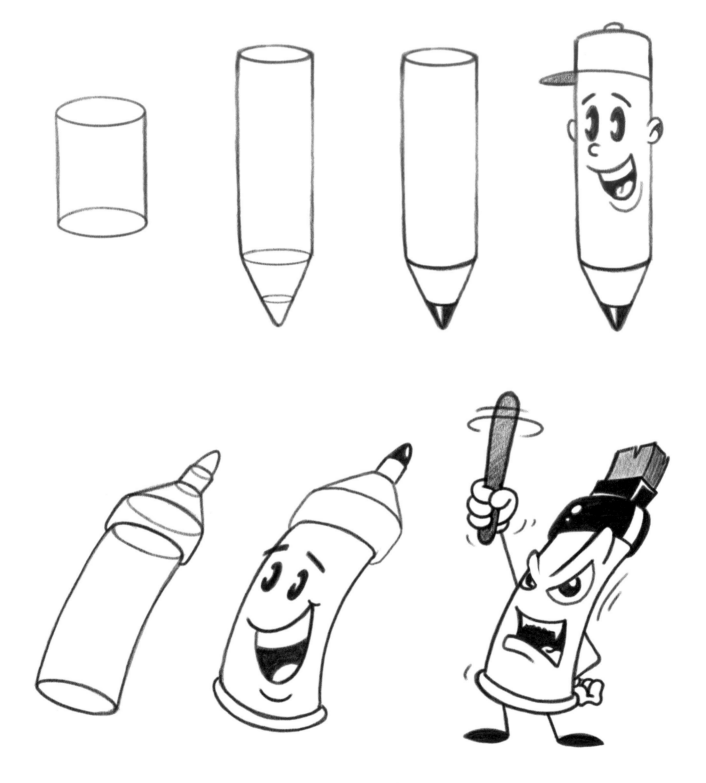

EXERCISE

Complete the character at different levels of difficulty. Finalize the figures by adding the missing lines to the templates below.

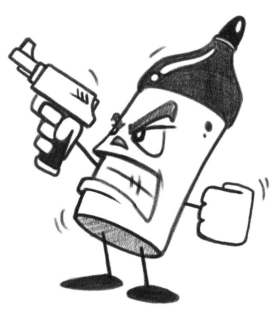

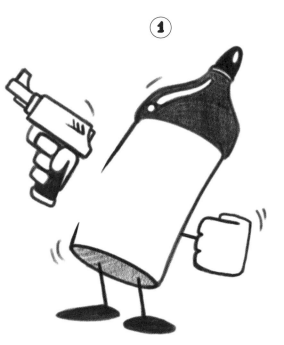

(1)

(2)

(3)

NON-HUMAN CHARACTERS:
THE ROLLER & THE BOOM BOX

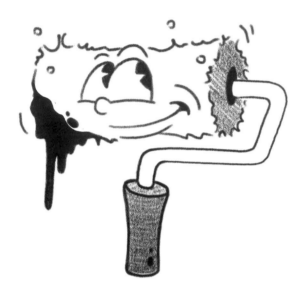

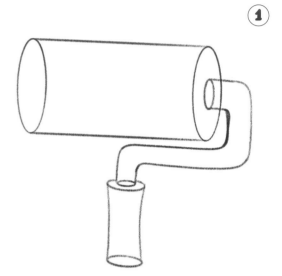

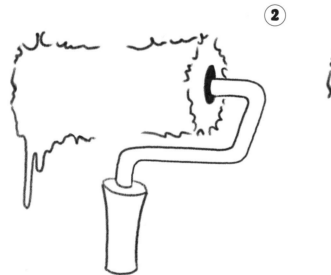

Complete the character at different levels of difficulty. Finalize the figures by adding the missing lines to the templates below.

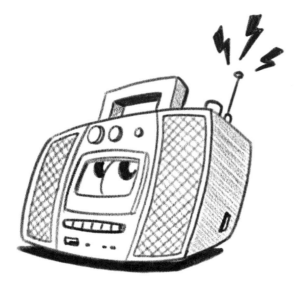 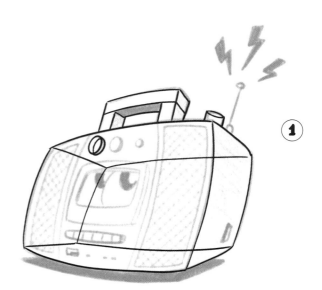

NON-HUMAN CHARACTERS: THE FLYING EYEBALL

The flying eyeball is a nice old school character, and similar to
other non-human characters it's relatively easy to draw.

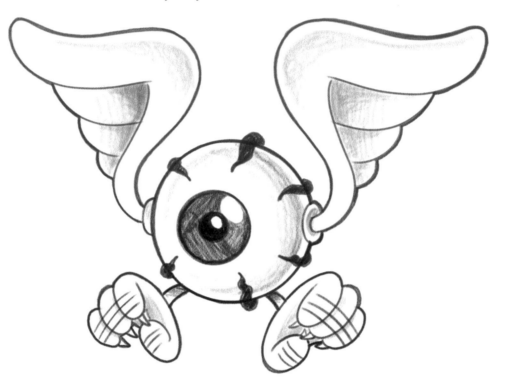

The eyeball is based on circles. The position of the pupil determines the direction in which the eye is looking. The wings can be of any type, such as Angel's Wings or Devil's Wings. The feet usually resemble the claws of a bird of prey.

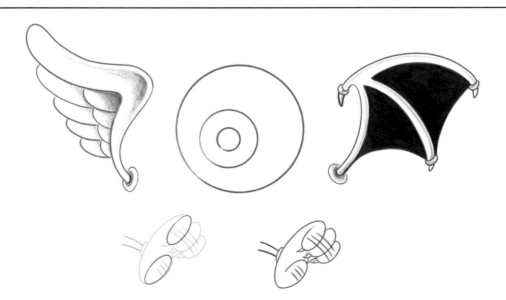

EXERCISE

Complete the character at different levels of difficulty. Finalize the figures by adding the missing lines to the templates below.

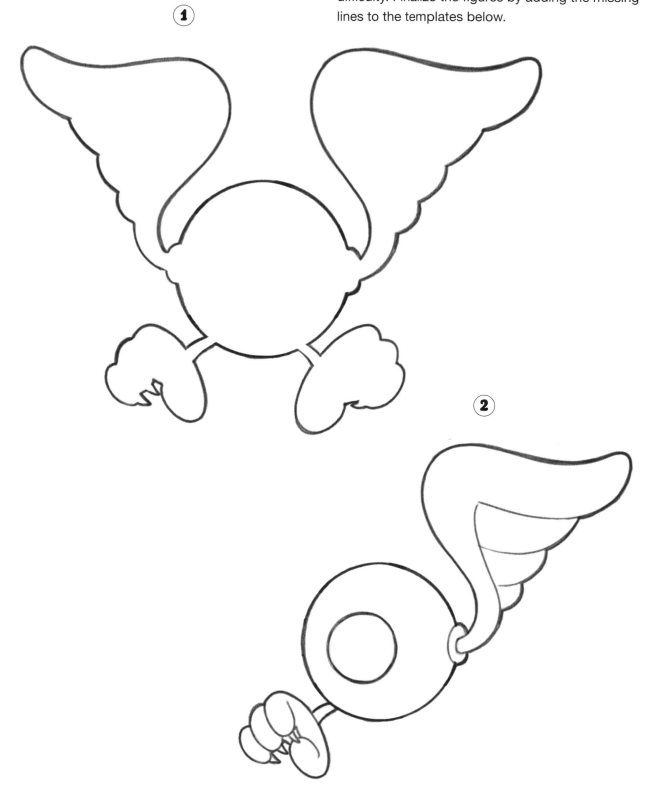

MORE GRAFFITI BOOKS

GRAFFITI FOR BEGINNERS

ISBN 978-91-88369-50-5

AMERICAN GRAFFITI COLORING BOOK

ISBN 978-91-88369-58-1

GRAFFITI COOKBOOK

ISBN 978-91-88369-45-1

ALSO CHECK OUT

SNEAKER COLORING BOOK

ISBN 978-91-88369-43-7

HIP HOP COLORING BOOK

ISBN 978-91-85639-83-0

BANKSY COLORING BOOK

ISBN 978-91-85639-75-5

DOKUMENT PRESS

www.dokument.org
info@dokument.org